THE INFECTIOUS DISEASE
COLOURING BOOK

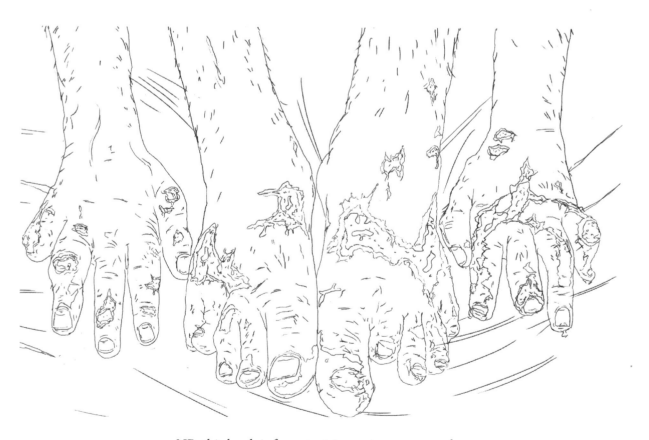

NB: this book is for entertainment purposes only

Published by Gizzy Books LTD 2016

Herpes simplex

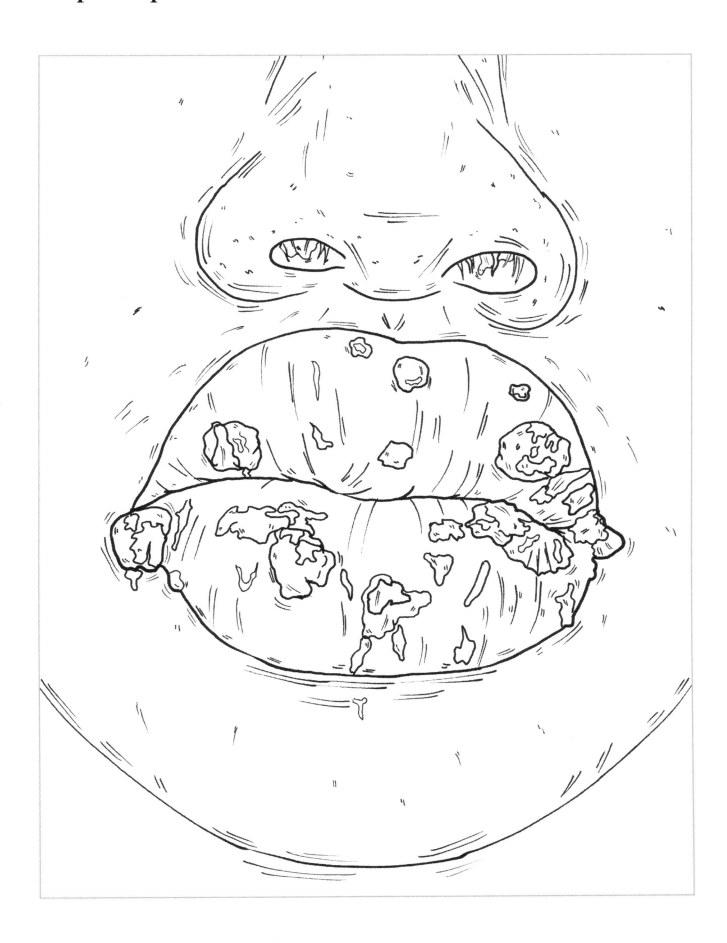

Flesh-eating bacteria
(*Necrotizing fasciitis*)

A rare infection of the skin and subcutaneous tissues, Necrotizing Fasciitis progresses rapidly and can be caused by many types of bacteria.

Flesh-eating bacteria
(*Necrotizing fasciitis*)

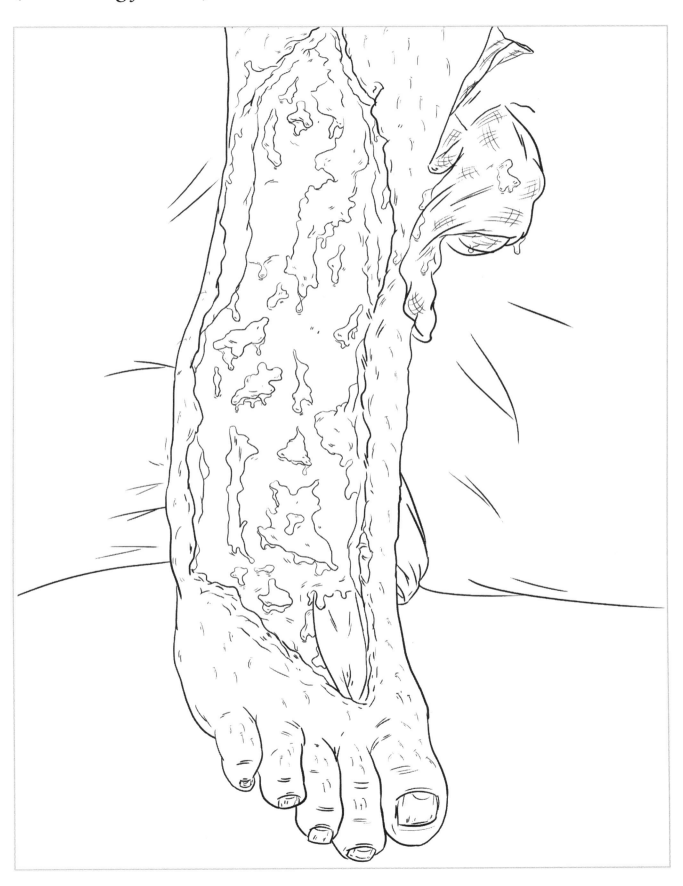

Lymphatic filariasis
(Elephantitis)

Caused by an infection of microscopic parasitic worms in the lymphatic system, it is spread by the bites of infected mosquitos. If the worms block the flow of in the lymphatic fluid (lymph) severe swelling in the lower part of the body can occur.

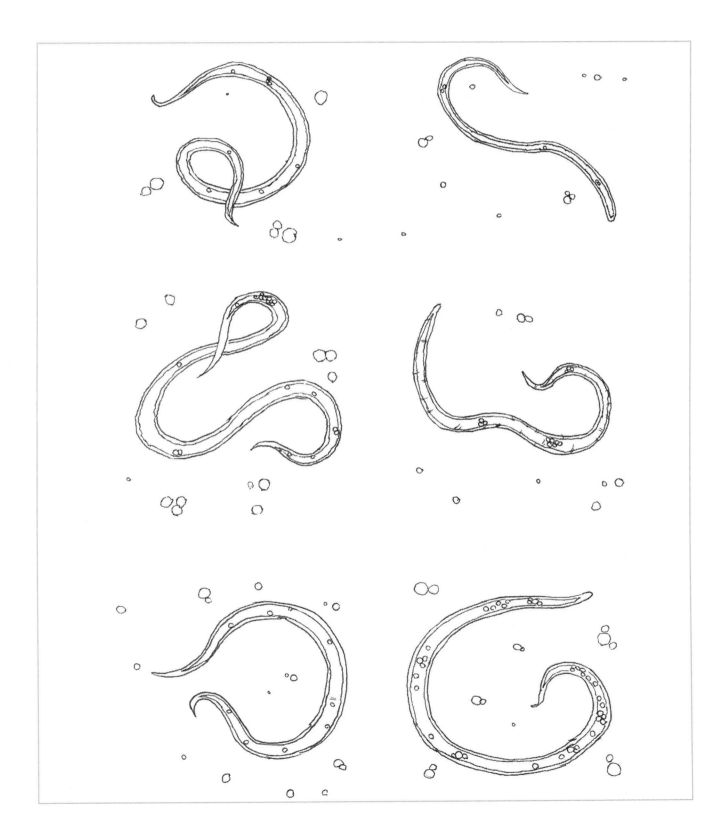

Lymphatic filariasis
(Elephantitis)

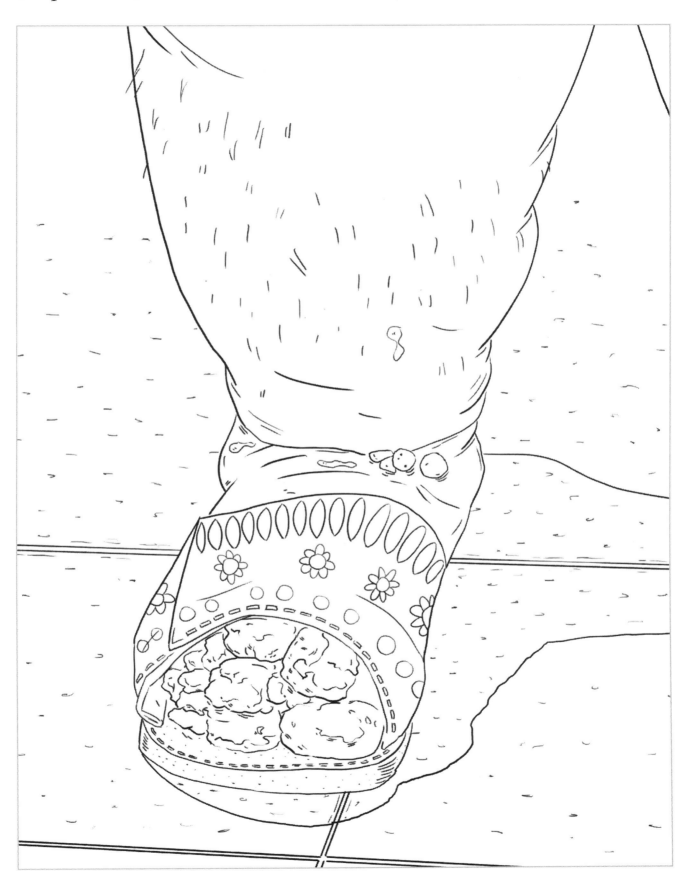

Syphilis
(Treponema pallidum)

A sexually transmitted bacterial infection, symptoms can vary depending on which of the four stages it presents. The first stage typically shows as a single genital ulcer. In the second stage, it presents as a rash, mainly on the palms of the hands or the soles of the feet. In a latent stage, there can be no or few symptoms. In the tertiary stage, it can cause heart problems, neurological problems and gummas.

Syphilis
(Treponema pallidum)

Smallpox
(*Variola major and Variola minor*)

Now eradicated, smallpox was an infectious viral disease causing a characteristic rash on the skin.

Smallpox
(*Variola major and Variola minor*)

Echinococcosis
(hydatid disease)

Caused by Echinococcus type tapeworms, which like many other parasites, have a complex life cycle. The adult tapeworm lives in primary hosts: predators such as dogs, foxes or wolves. These primary hosts have contracted the tapeworm by eating the organs of secondary hosts (such as sheep, goats or rodents) which contain hydatid cysts. The organs of these secondary hosts were infected when the secondary host ingested eggs excreted by a primary host. These eggs hatched and larvae burrowed through into organs such as the liver and lungs before forming cysts. Humans are not a normal part of this lifecycle but can become accidental secondary hosts when they ingest eggs excreted by a primary host. Larvae can hatch from the eggs, burrowing through the intestinal wall and forming cysts in the liver, lungs, spleen, heart, kidneys and brain.

Echinococcosis
(hydatid disease)

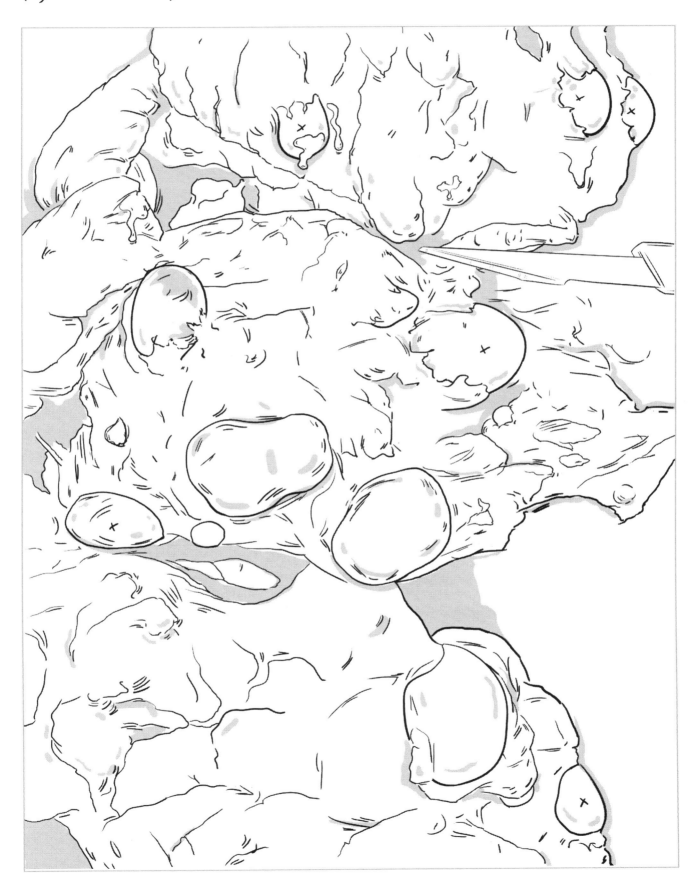

Raccoon Roundworm
(*Baylisascaris procyonis*)

Infection can occur through consuming food or drink contaminated with eggs from faeces. If the larvae are in a host not necessary for development, they burrow through the intestinal wall, break into the bloodstream and enter various organs, including the spinal cord, eyes, liver and brain. This can cause behavioural changes by damaging parts of the brain. The host then becomes more vulnerable to prey, increasing the chance of predation, and as a consequence, increasing the chance of the larva entering the intestines of a new host. Once in the digestive system of the primary host, the larva mature, mate and produce eggs, which are passed in the faeces.

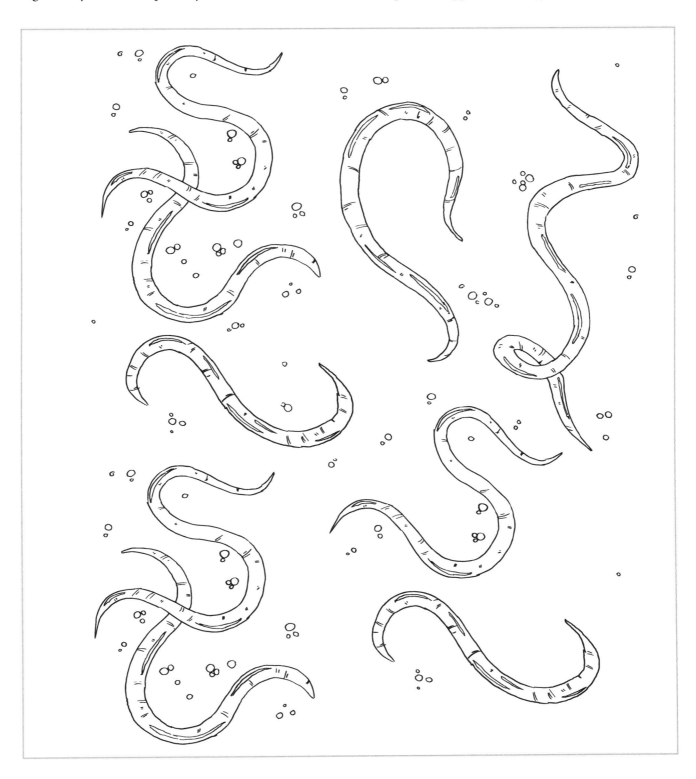

Raccoon Roundworm
(*Baylisascaris procyonis*)

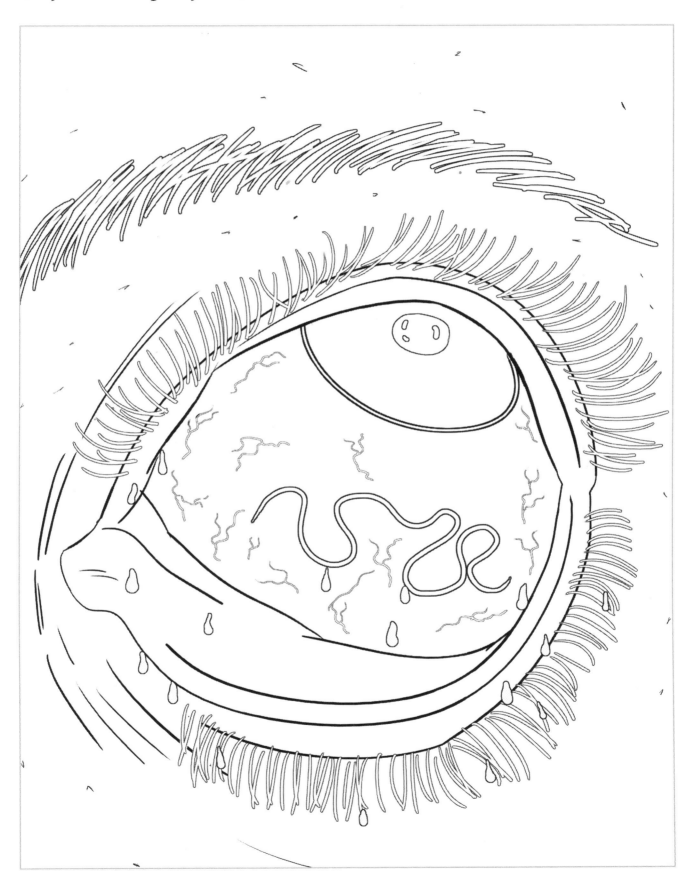

Bot Fly
(*Dermatobia hominis*)

Dermatobia hominis is a species of fly with larvae that parasitise humans, as well as other animals. The female botfly uses mosquitoes to transport their eggs. It captures a mosquito and sticks eggs to its body, then releases it. The eggs hatch when the mosquito feeds, triggered by the warmth of a mammal body. The larvae burrow into the mammal's skin, where they mature for approximately eight weeks.

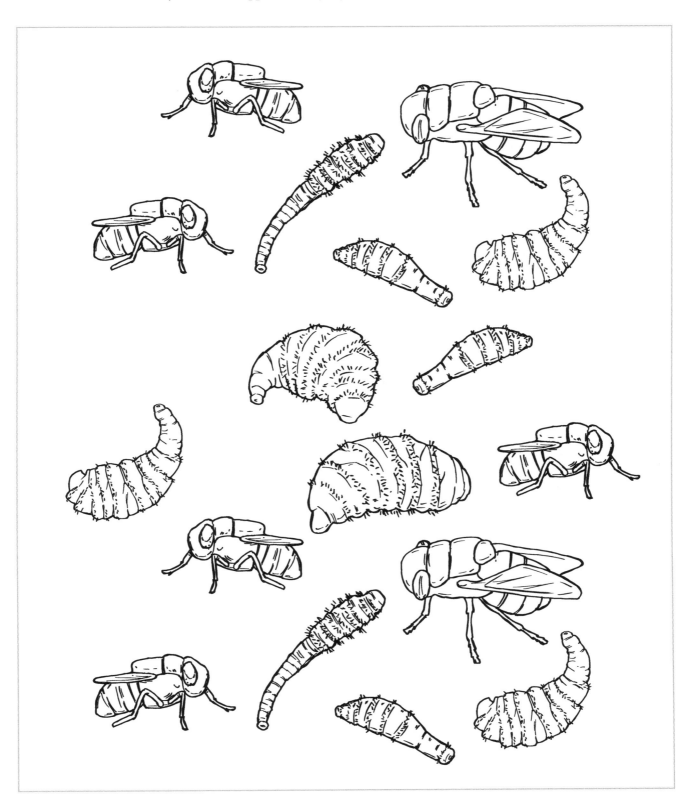

Bot Fly
(*Dermatobia hominis*)

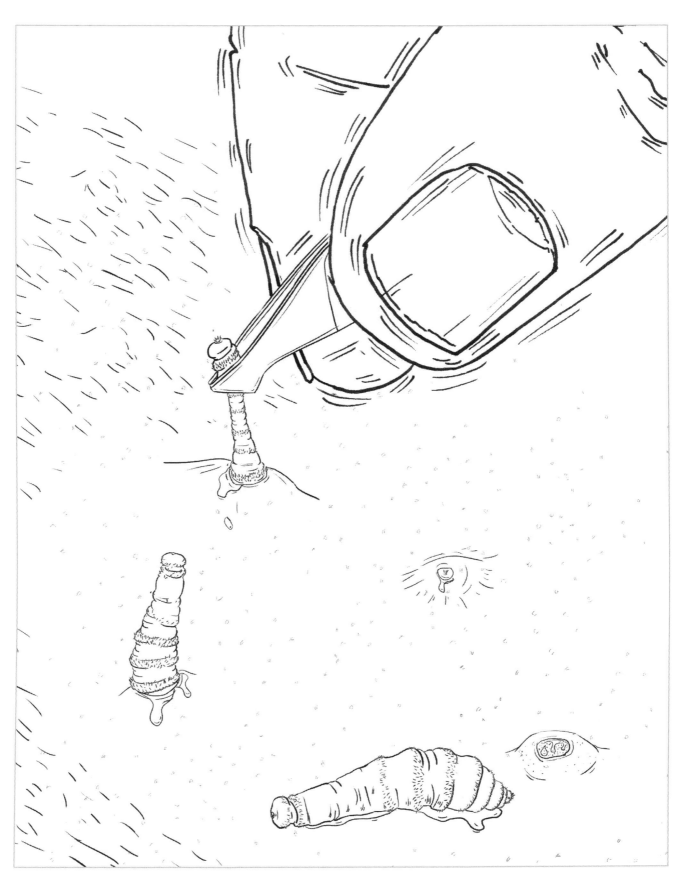

Chigoe Flea
(Tunga penetrans)

A small insect which parasitises humans and other primates, female Chigoe fleas with fertilised eggs will dig into the skin on unprotected feet. They stay in the skin while their abdomen swells with up to a thousand developed eggs, which are then released to the ground.

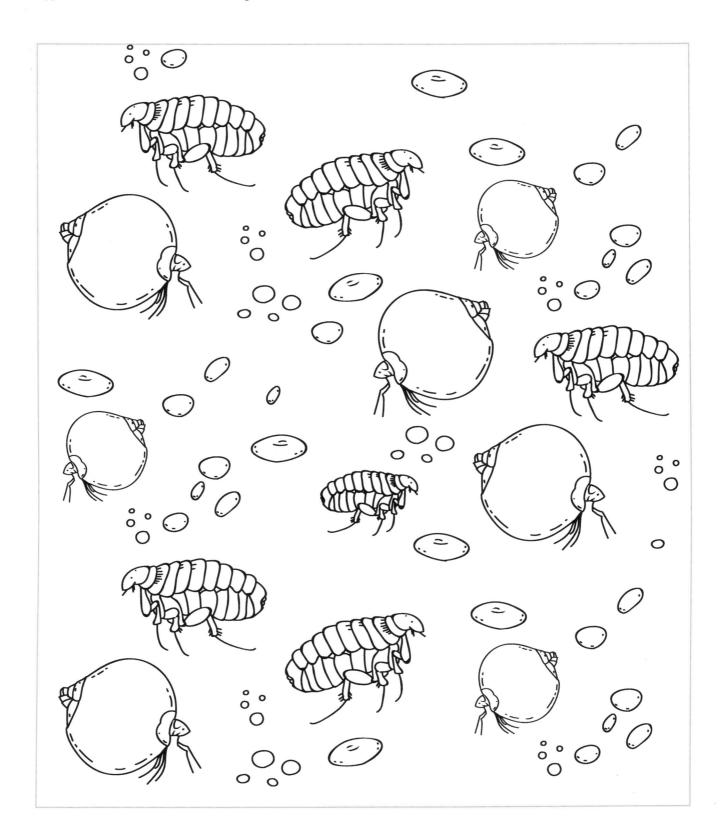

Chigoe Flea
(Tunga penetrans)

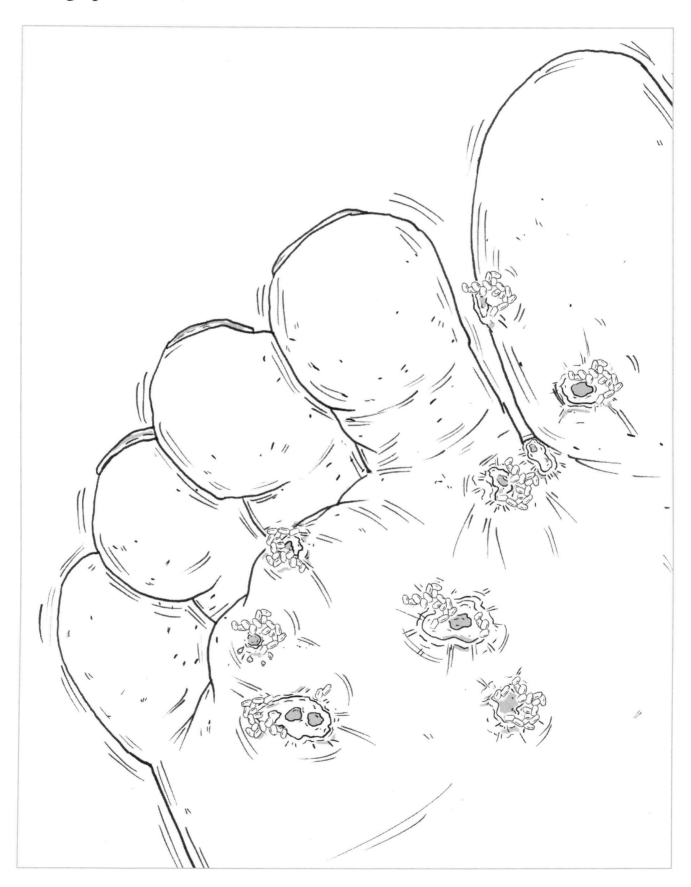

Fungal infection

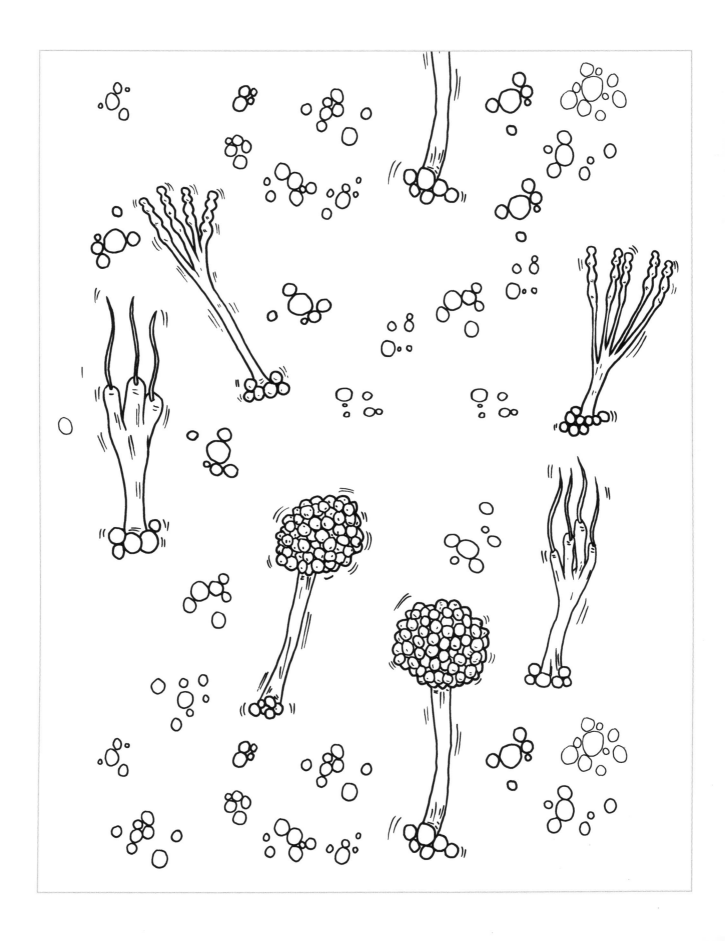

Fungal infection

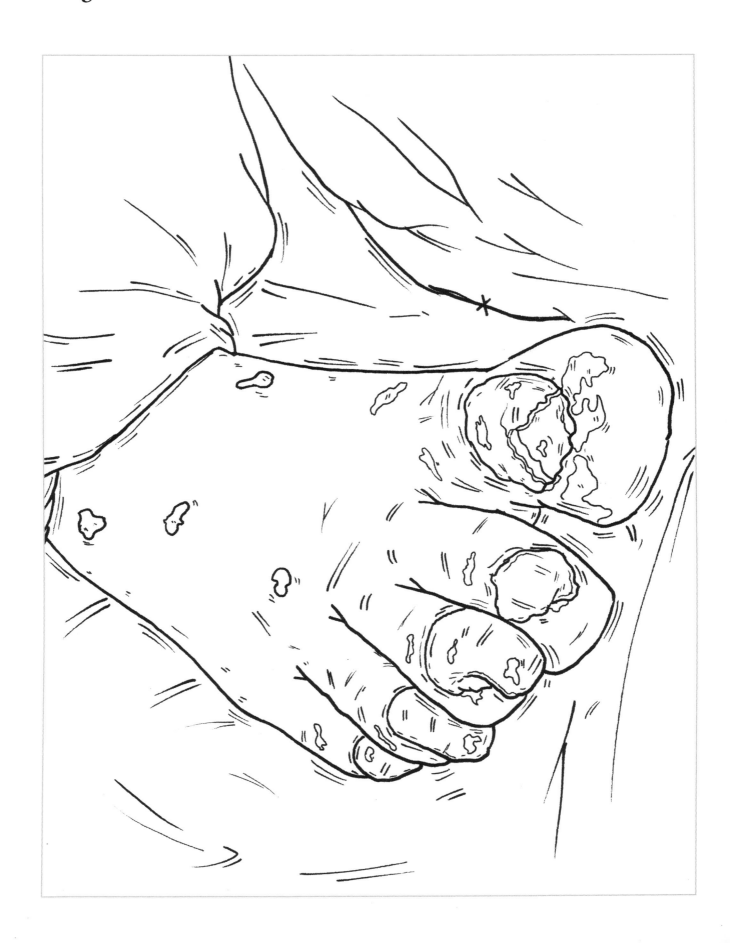

Trachoma
(*Chlamydia trachomatis*)

Infection with Chlamydia trachomatis causes a roughening of the inside of the eyelids, which can lead to damage of the outer surface of the eye and blindness.

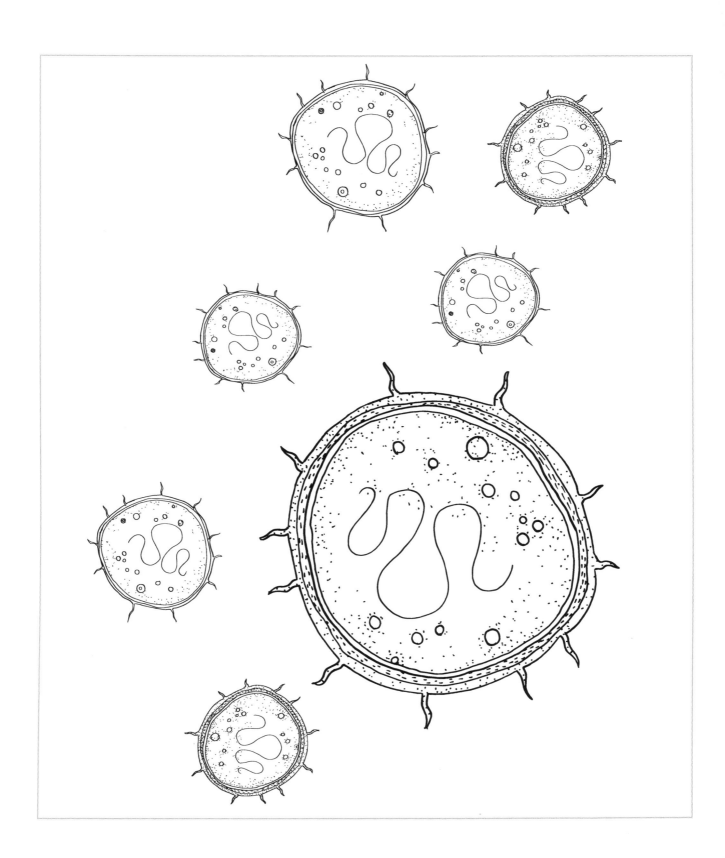

Trachoma

(*Chlamydia trachomatis*)

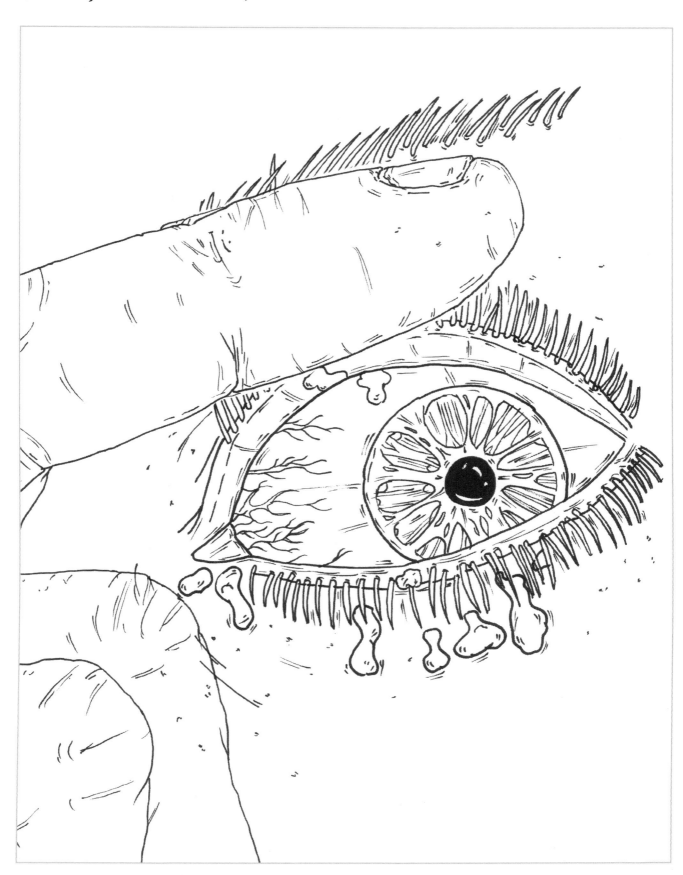

Pork Tapeworm
(Taenia solium)

The so-called pork tapeworm actually has humans as its primary host.
Primary infection is the most common and happens when humans consume infected pork (which is also raw or undercooked). The adult tapeworm lives within the human intestine, with a long, flat, ribbon-like body typically measuring 2 to 3 meters long, but can grow to more than 8m. Eggs are passed into the environment through human faeces, where they can be consumed by pigs. Once inside pigs, the eggs hatch and larvae burrow into tissue, where they settle to form cysts and can infect humans who eat the undercooked meat. More dangerous, however, is a secondary infection, when humans consume water or food contaminated by the faeces of infected humans. As with pigs, the eggs hatch and larvae burrow into tissue, where they are carried in the bloodstream into organs including the brain and form cysts.

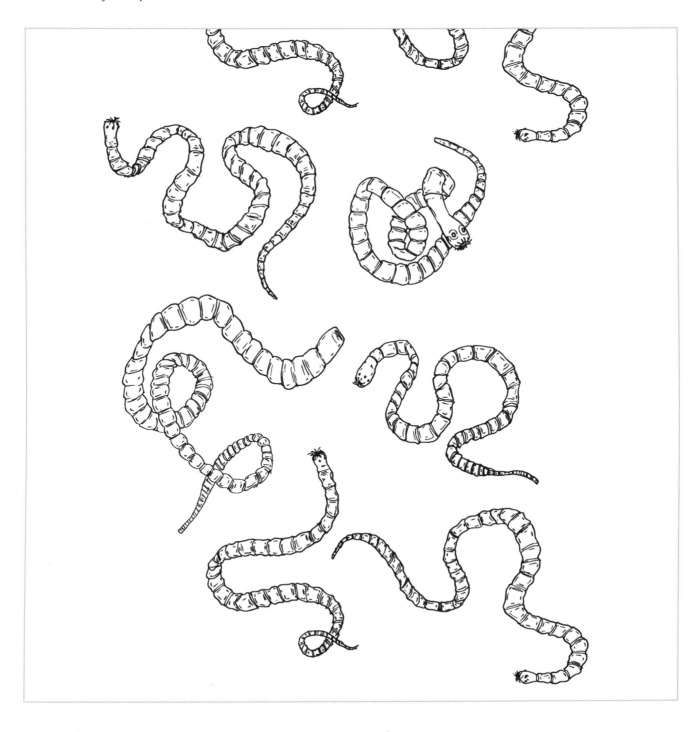

Pork Tapeworm
(Taenia solium)

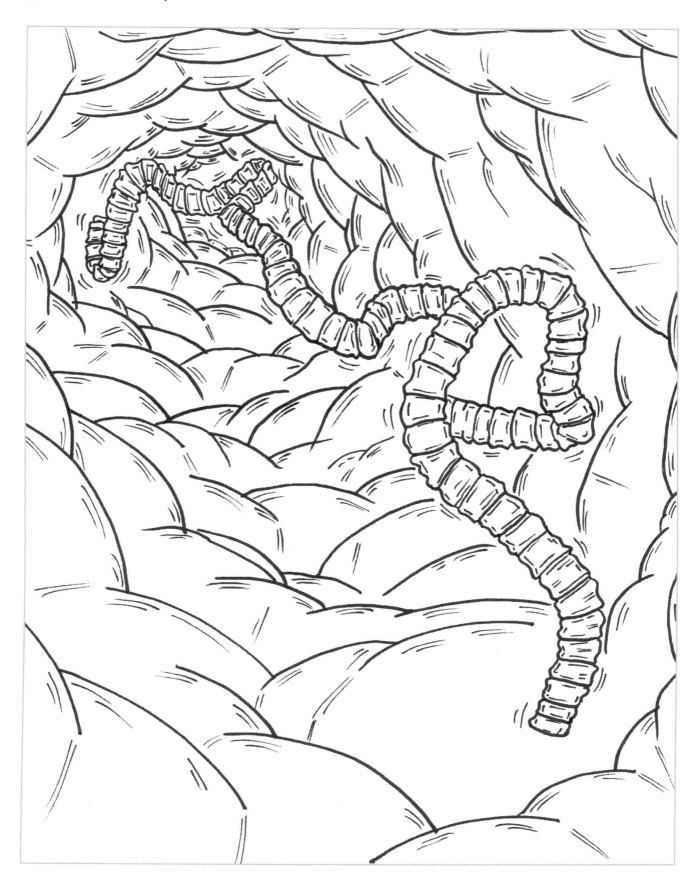

Ringworm
(Dermatophytosis)

Caused by around 40 types of fungi which can infect the skin, usually causing a circular, red, flaky rash.

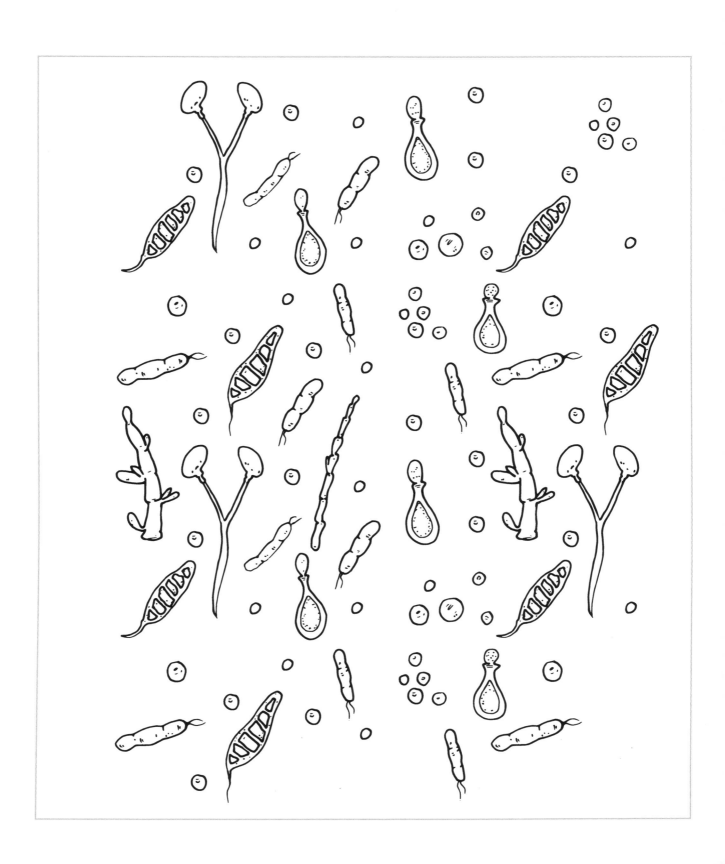

Ringworm
(Dermatophytosis)

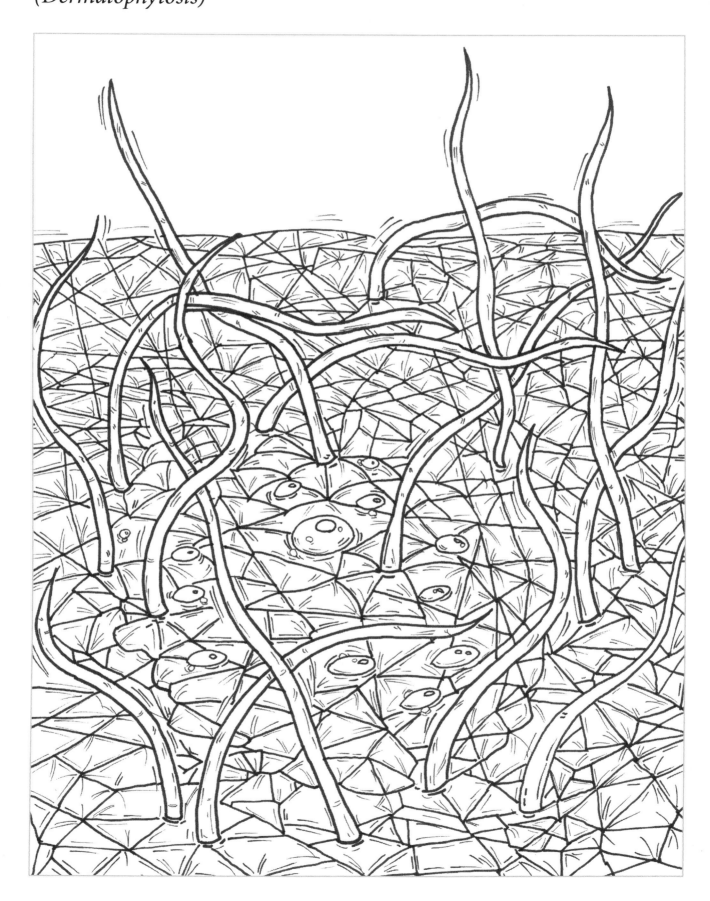

Methicillin-resistant Staphylococcus aureus
(Staphylococcus aureus)

MRSA causes a staph infection which is difficult to treat, as it is resistant to multiple antibiotics. The bacteria responsible are common in hospitals, residential nursing homes and prisons. People who have weakened immune systems or invasive devices, such as catheters, have a higher risk of infection.

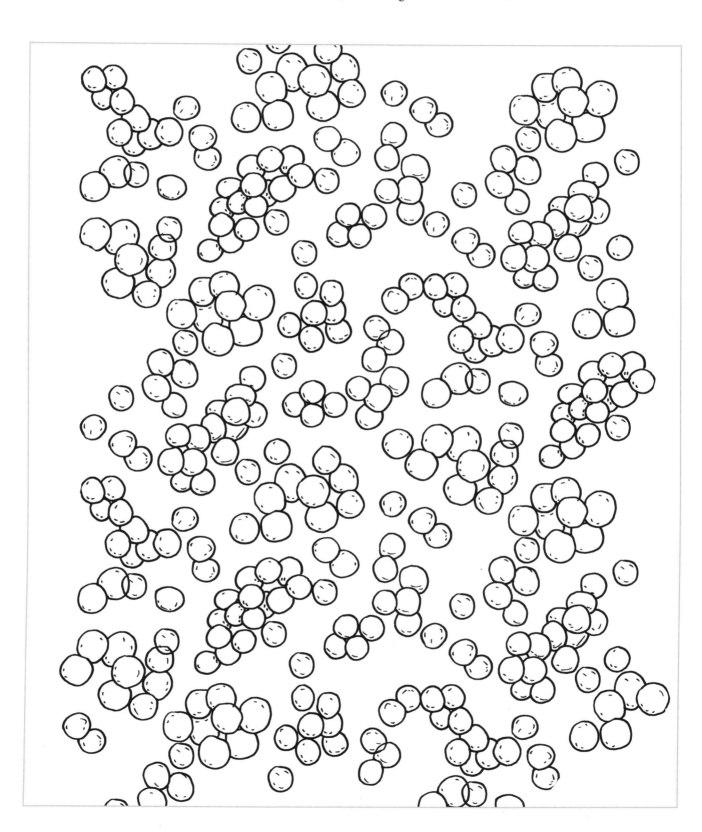

Methicillin-resistant Staphylococcus aureus

(Staphylococcus aureus)

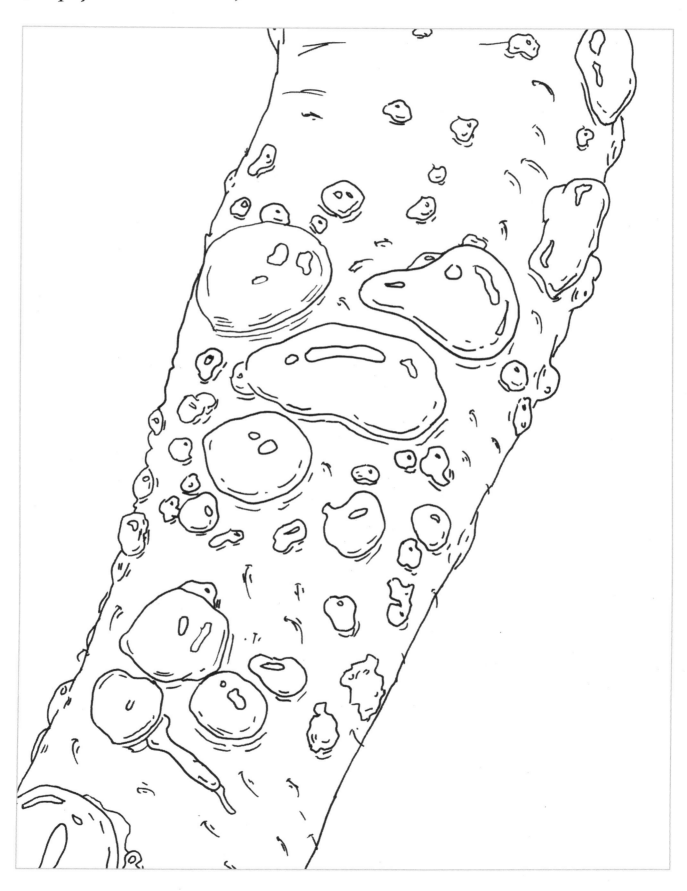

Leishmaniasis

Caused by Leishmania, tiny single-celled parasites which live within infected human cells. Leishmania is transmitted to humans through bites from infected sand flies on exposed skin, causing lesions.

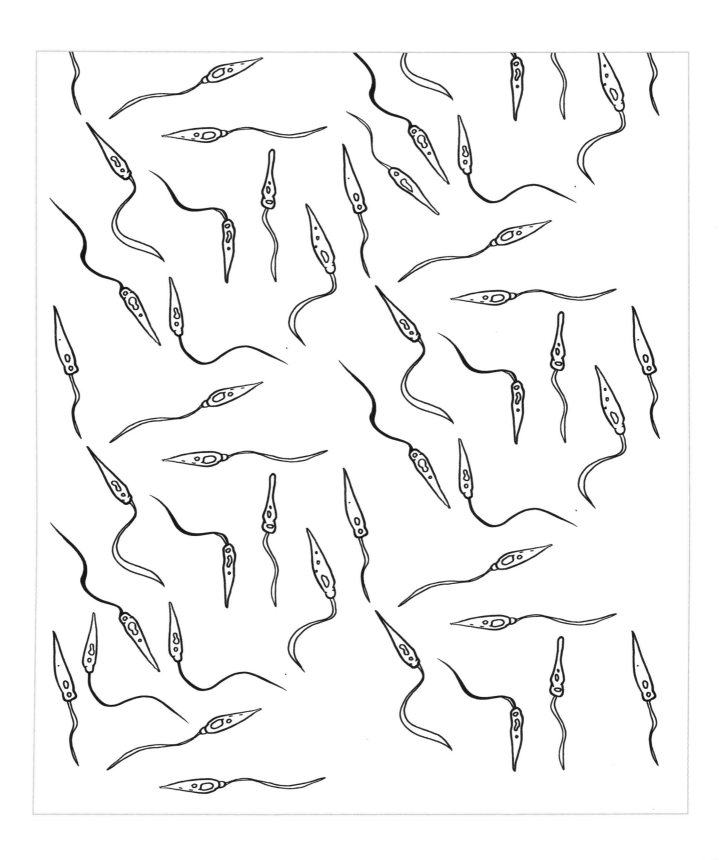

Leishmaniasis

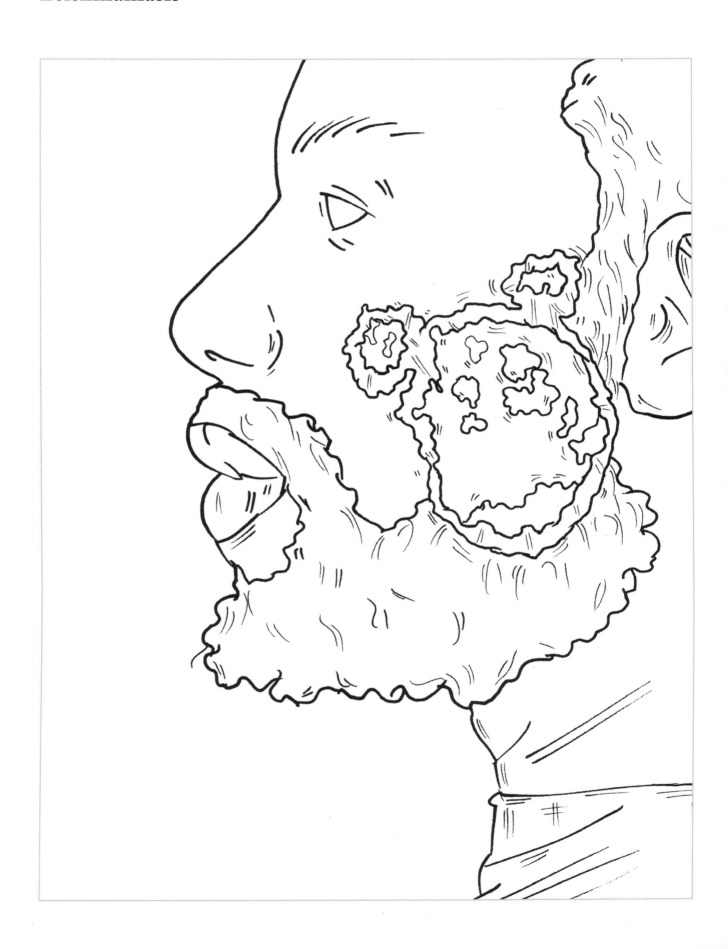

Warts
(human papillomavirus)

Caused by human papillomavirus (HPV) a DNA virus from the papillomavirus family. Over 170 types are known and cause a variety of warts including common, plantar warts, filiform warts, and genital warts. HPV is believed to enter the body through damaged skin, infecting most people some point in their lives.

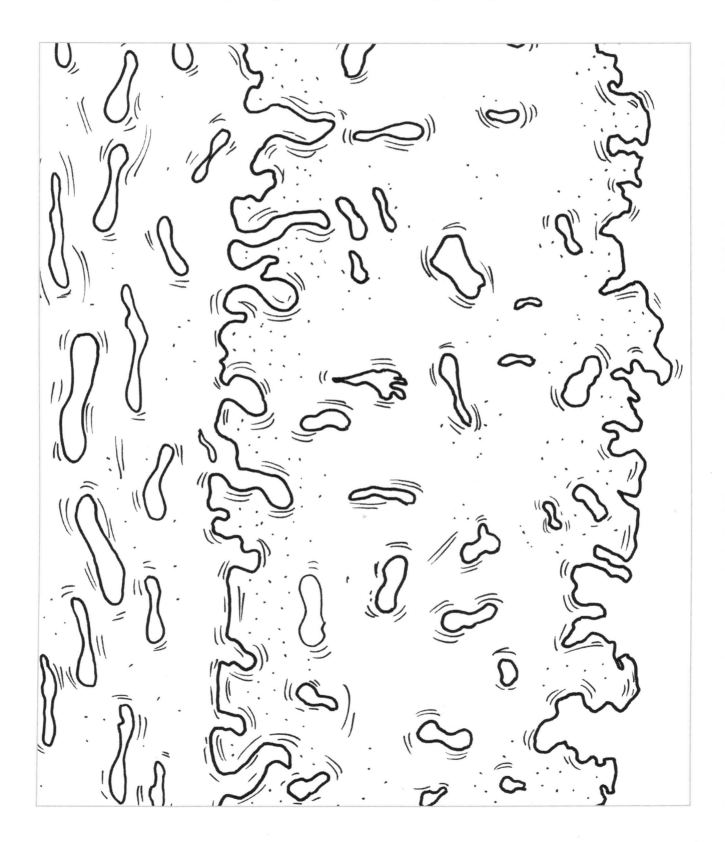

Warts

(human papillomavirus)

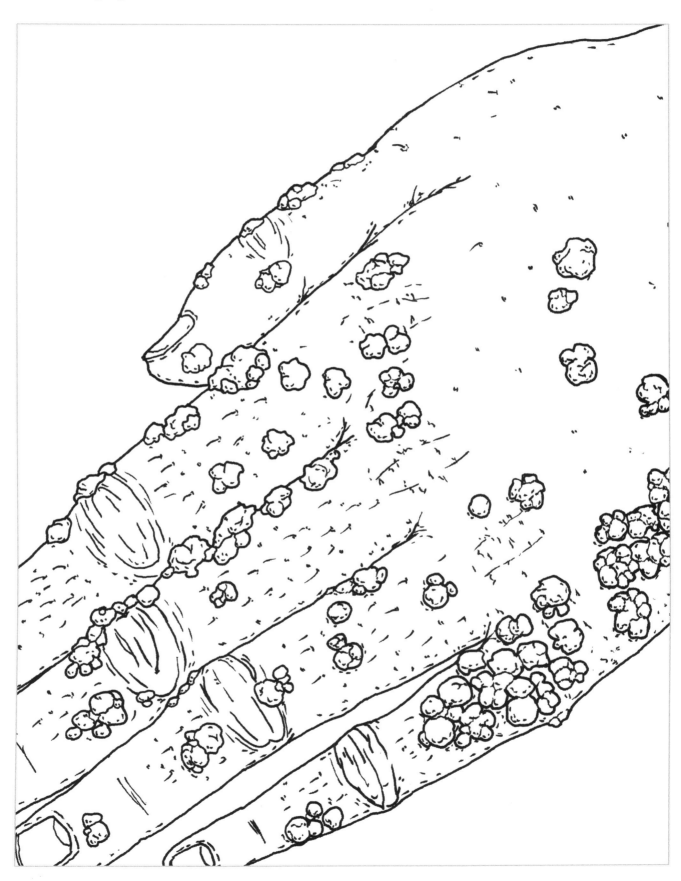

Pinworms / Threadworms
(*Enterobius vermicularis*)

The life cycle begins when eggs are ingested by humans. Larvae hatch from the eggs and travel through the human intestines. The male and female pinworms mate in the small intestine, after which the males usually die. The female pinworm then attaches itself to the intestinal wall and begins to fill with eggs. Once full, they migrate through the colon, towards the rectum. Emerging from the anus, they lay eggs on the skin around the anus, then die. What a life!

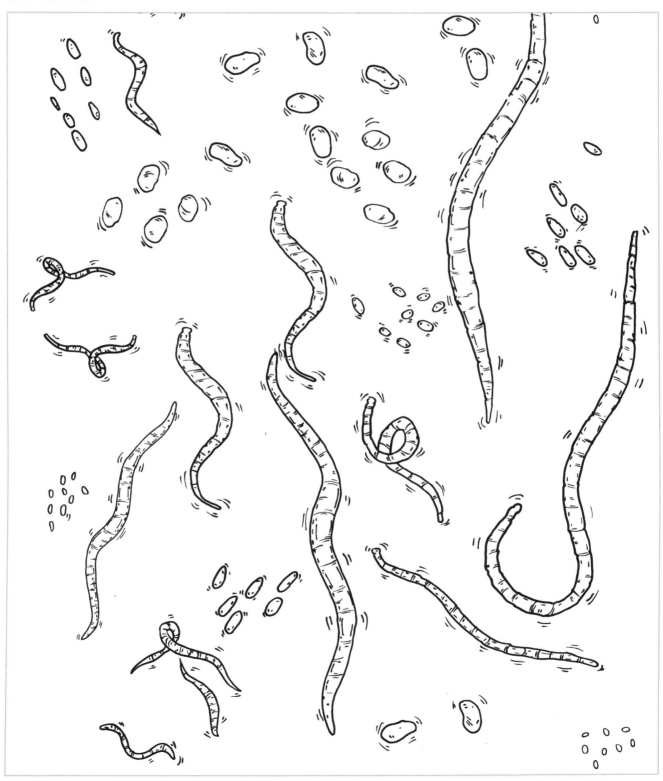

Pinworms / Threadworms
(*Enterobius vermicularis*)

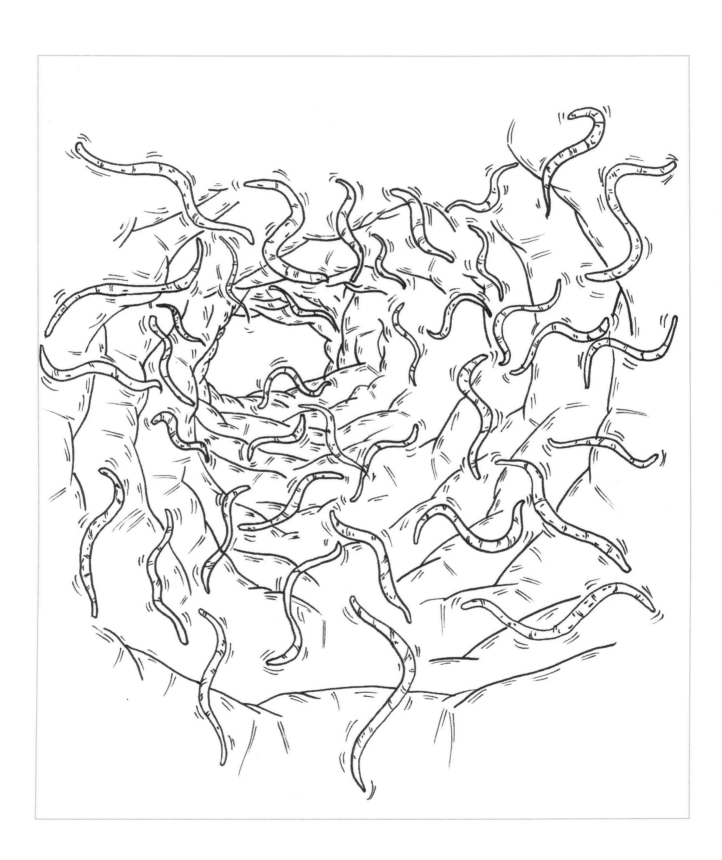

Gizzy books

Thank you for supporting this book!

I hope you don't feel too sick.
(Please leave a review on Amazon if you enjoyed it. I would be very grateful!)
- *Nick*

More books: gizzybooks.com

The Disgusting Animal
Coloring Book

Insect colouring book

…coming soon

Published by Gizzy Books LTD 2016
Copyright © Nicholas Wright

ISBN: 978-0-9955065-0-3

Made in the USA
San Bernardino, CA
11 December 2019